Funky 🐾 Cats

COLORING BOOK

Brenda Abdoyan

DESIGN ORIGINALS
an Imprint of Fox Chapel Publishing
www.d-originals.com

Basic Tools for Adding Color

Coloring, luckily, offers many options for how to apply your hues. Here you can see the same cat face colored three different times. Each cat was colored using a different coloring tool. Method #1 was colored with permanent markers; method #2 was colored using colored pencils and watercolor pencils combined (following the manufacturer's instructions); and, finally, method #3 was colored using basic watercolor paint. Not only are your color schemes unlimited (as you can see on the next page), but you also have a lot of tools at your disposal. It's totally up to you to decide what you like best.

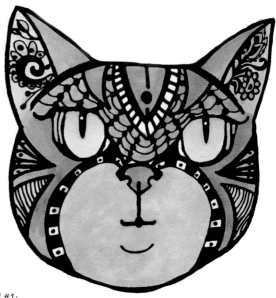

Method #1:
Permanent Markers

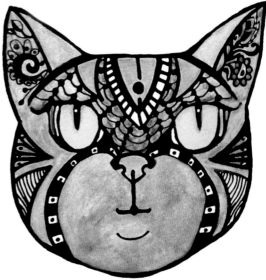

Method #2:
Colored Pencils and Watercolor Pencils

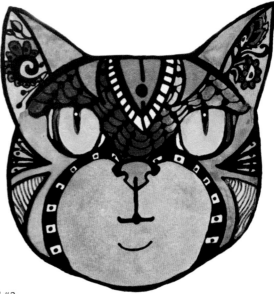

Method #3:
Watercolor Paint

Basic Coloring Options

Coloring an image is like bringing to life. The best part of having the ability to give life to a drawn image is that there is no limit to what you can do! You can decide how your version of the image will look. Anything goes; whatever you can imagine, you can color.

In my colored examples, I used the same original cat drawing with a few color variations. However, not only did I add color, I also left some spaces completely without color. Then I decided to add more details to the eyes (with thin black accent lines), and add eyebrows and varying whiskers!

Relax and have fun! That is the only rule in your world full of color.

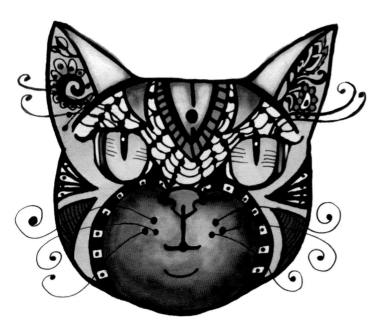

Pop art color scheme

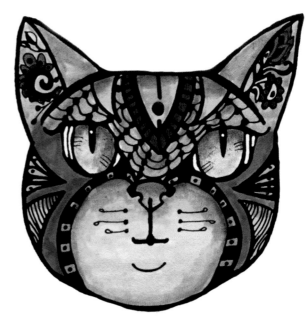

Cool color scheme

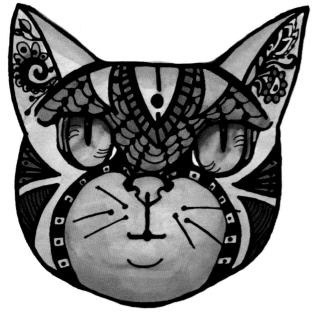

Decorative color scheme

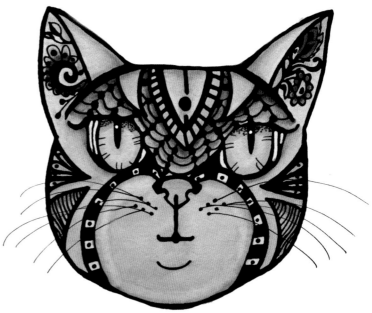

Natural color scheme

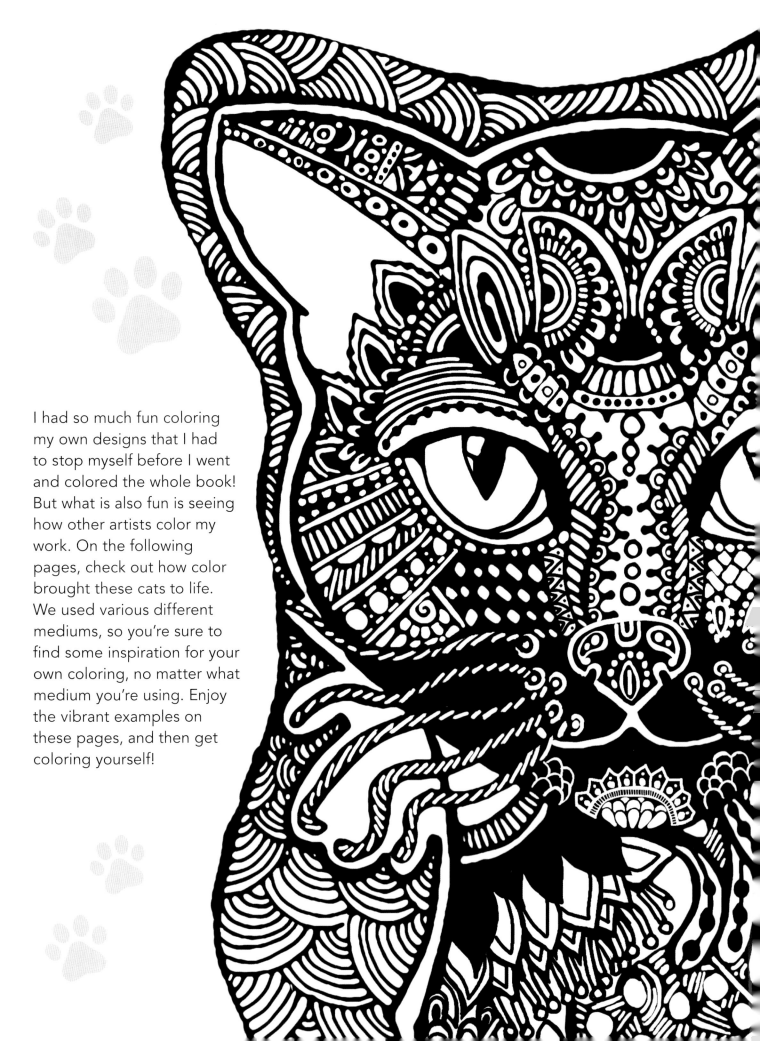

I had so much fun coloring my own designs that I had to stop myself before I went and colored the whole book! But what is also fun is seeing how other artists color my work. On the following pages, check out how color brought these cats to life. We used various different mediums, so you're sure to find some inspiration for your own coloring, no matter what medium you're using. Enjoy the vibrant examples on these pages, and then get coloring yourself!

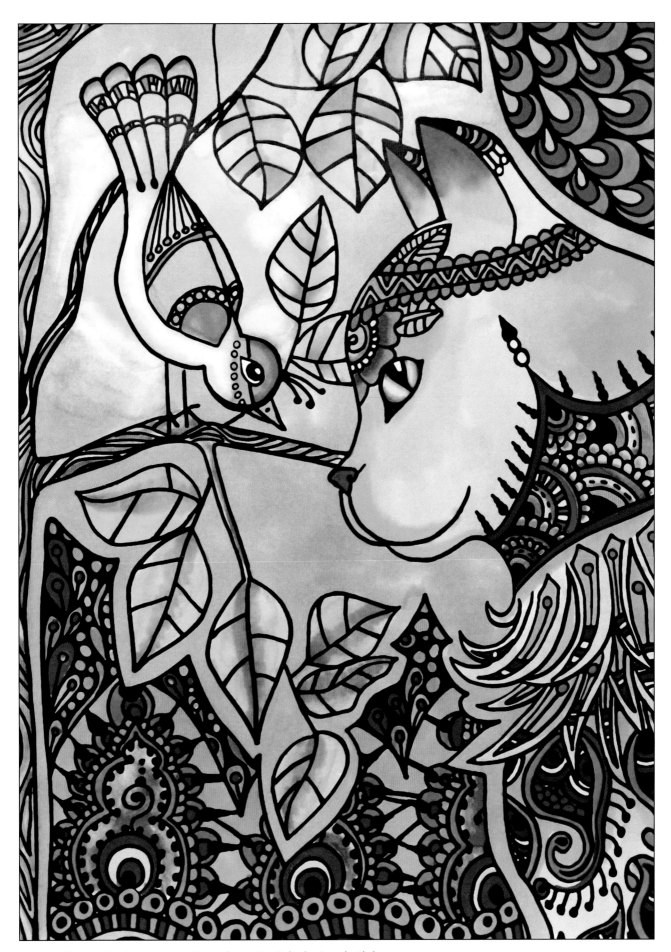

Markers (Sharpie, Tombow, Letraset ProMarkers, Bic). Color by Brenda Abdoyan.

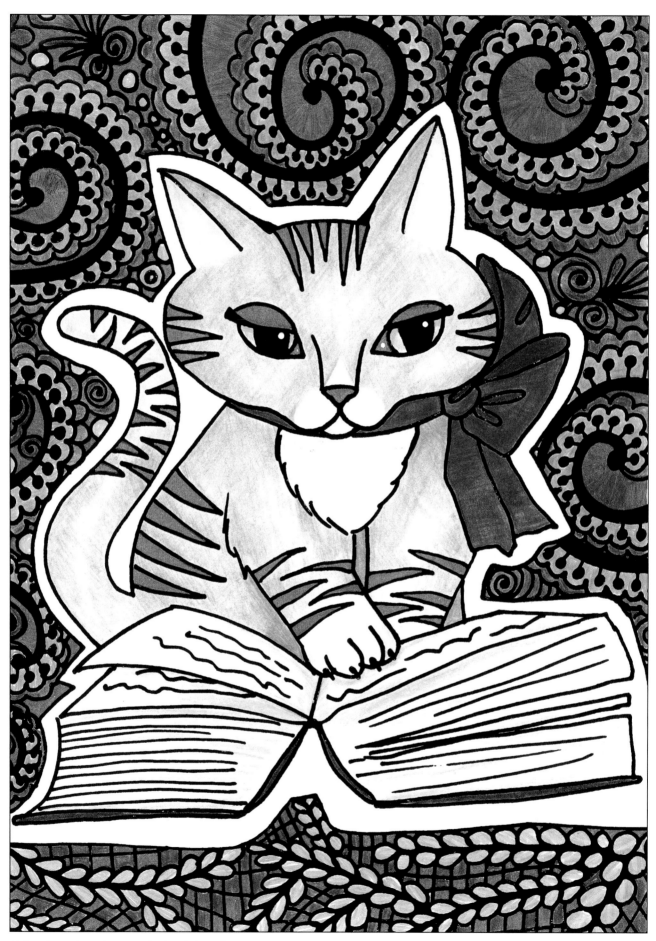

Colored pencils, gel pens. Color by Skyler Miller.

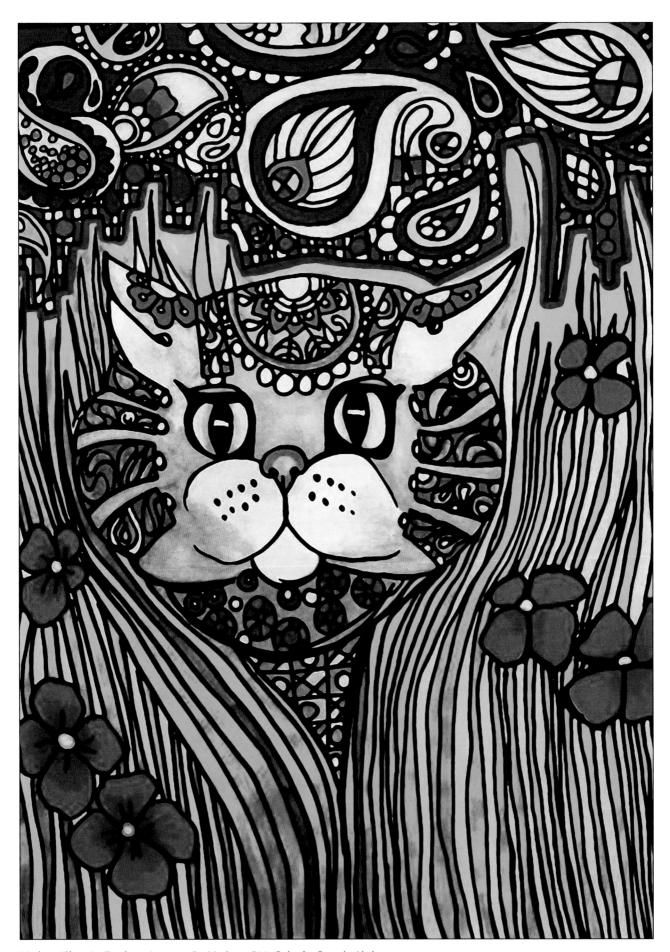

Markers (Sharpie, Tombow, Letraset ProMarkers, Bic). Color by Brenda Abdoyan.

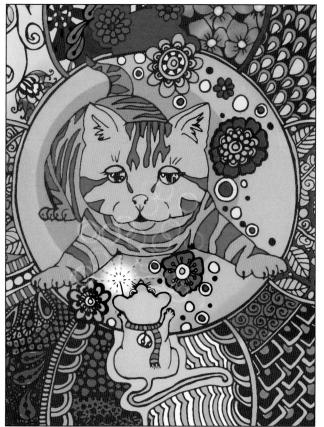

Markers (Sharpie, Tombow, Letraset ProMarkers, Bic).
Color by Brenda Abdoyan.

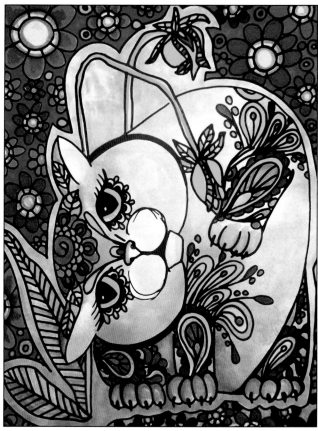

Markers (Sharpie, Tombow, Letraset ProMarkers, Bic).
Color by Brenda Abdoyan.

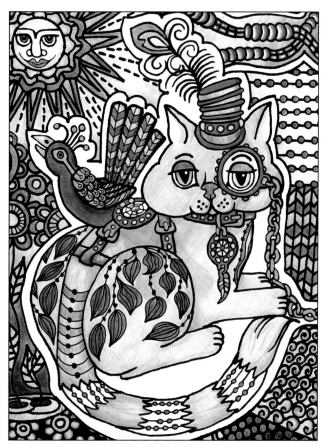

Colored pencils, gel pens.
Color by Skyler Miller.

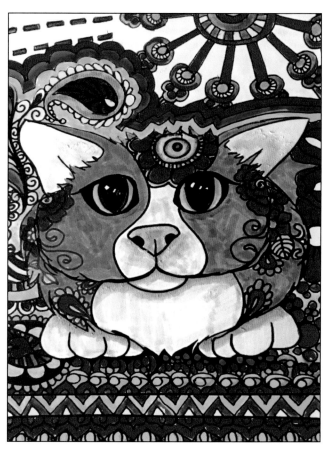

Markers (Sharpie, Tombow, Letraset ProMarkers, Bic).
Color by Brenda Abdoyan.

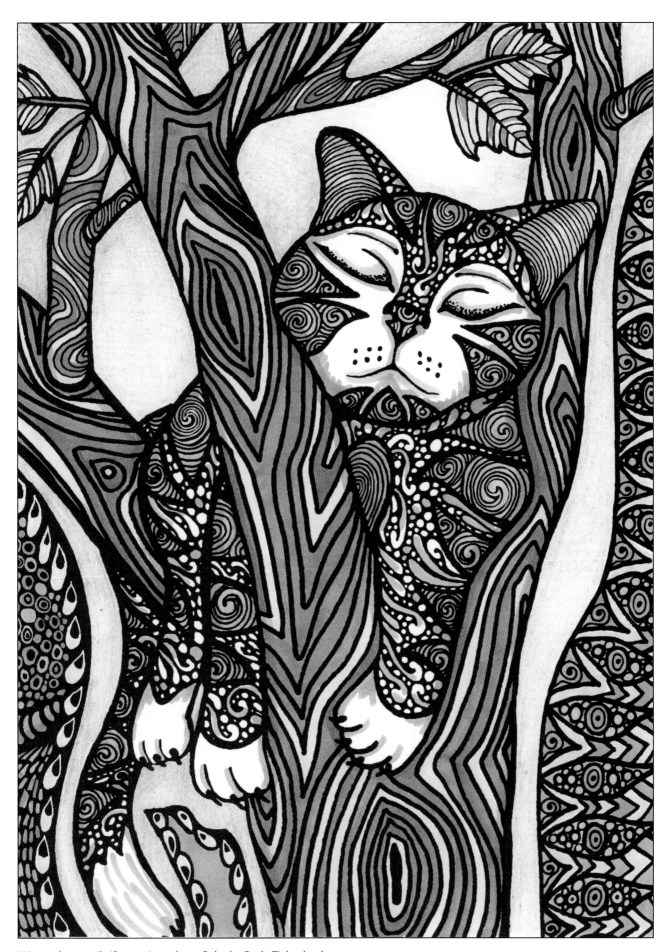

Watercolor pencils (Sargent), markers. Color by Darla Tjelmeland.

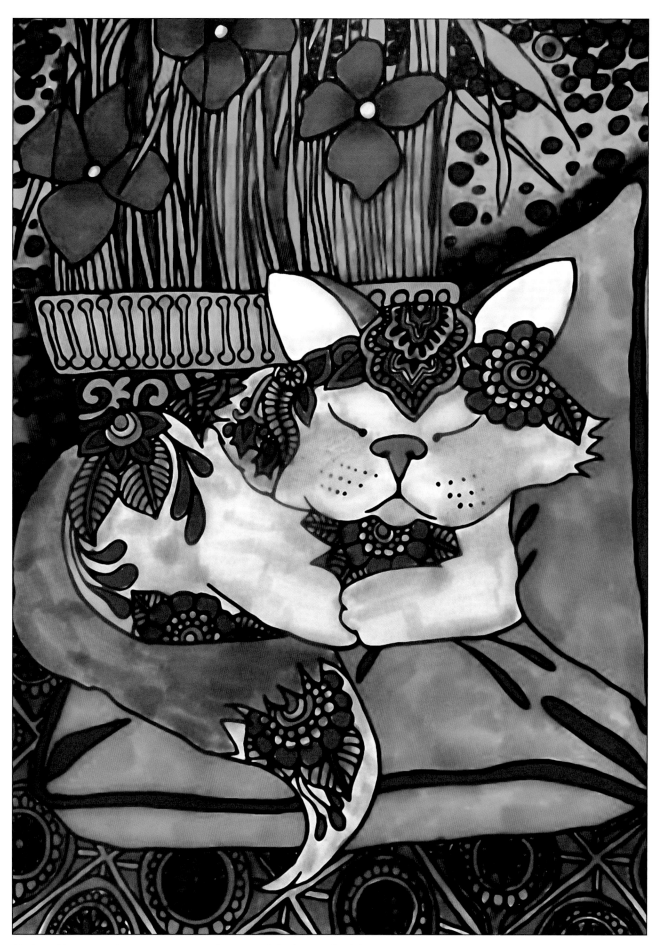

Markers (Sharpie, Tombow, Letraset ProMarkers, Bic). Color by Brenda Abdoyan.

Markers. Color by Elaine Sampson.

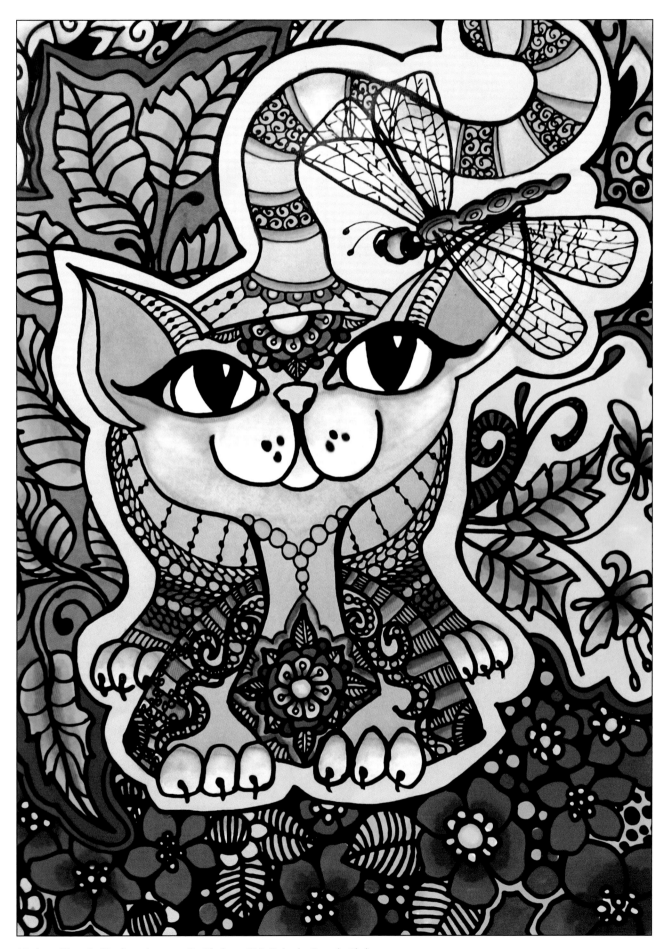

Markers (Sharpie, Tombow, Letraset ProMarkers, Bic). Color by Brenda Abdoyan.

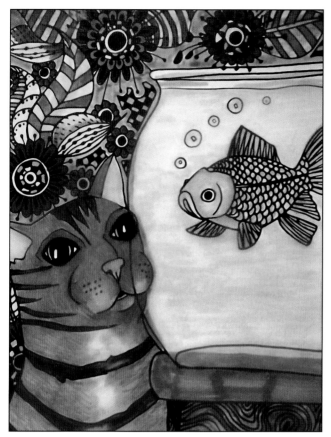

Markers (Sharpie, Tombow, Letraset ProMarkers, Bic).
Color by Brenda Abdoyan.

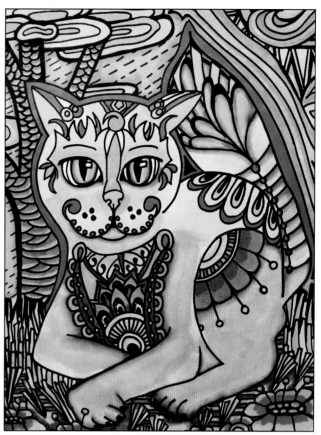

Markers (Sharpie, Tombow, Letraset ProMarkers, Bic).
Color by Brenda Abdoyan.

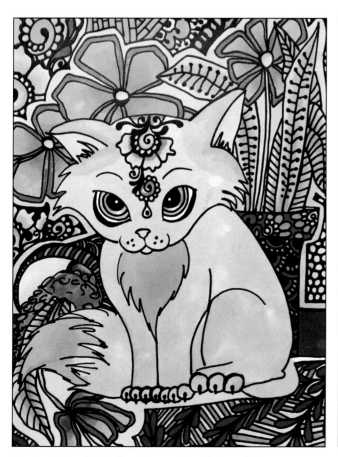

Markers (Sharpie, Tombow, Letraset ProMarkers, Bic).
Color by Brenda Abdoyan.

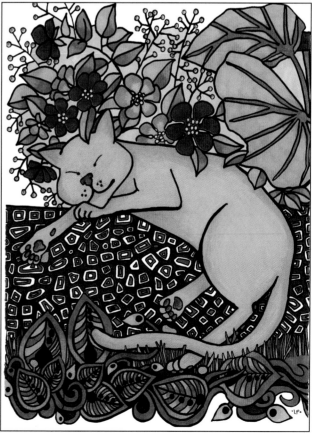

Markers (Chameleon), colored pencils (Prismacolor).
Color by Llara Pazdan.

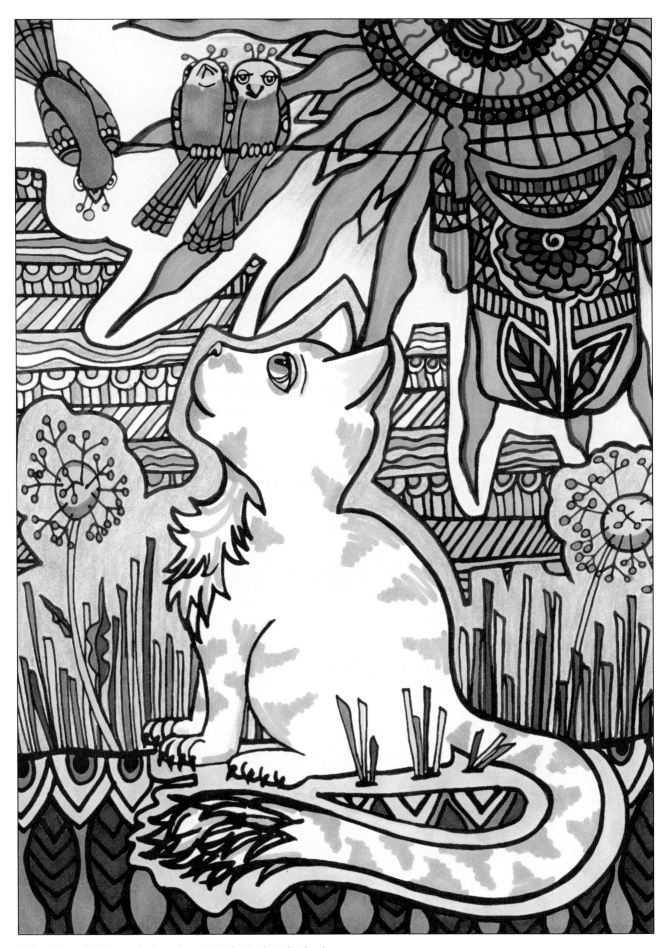

Colored pencils (Prismacolor), markers. Color by Darla Tjelmeland.

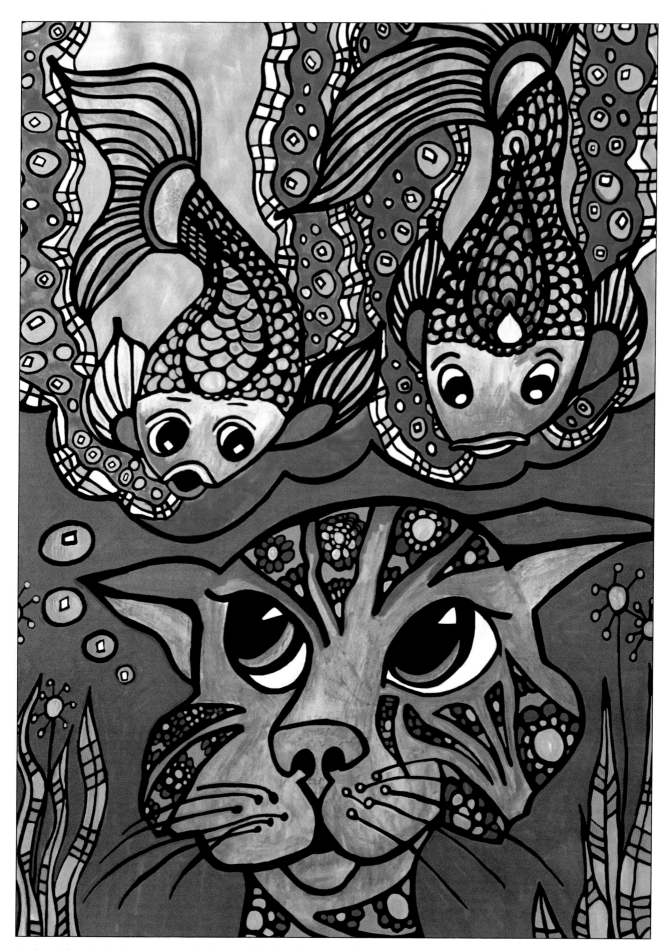

Markers (Sharpie, Tombow, Letraset ProMarkers, Bic). Color by Brenda Abdoyan.

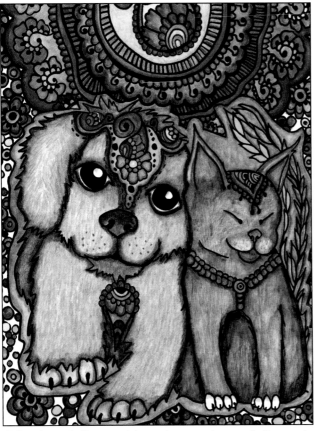

Colored pencils (Derwent Inktense), watercolor pencils (Derwent).
Color by Ninna Hellman.

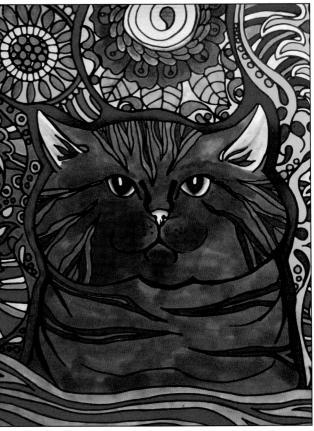

Markers (Sharpie, Tombow, Letraset ProMarkers, Bic).
Color by Brenda Abdoyan.

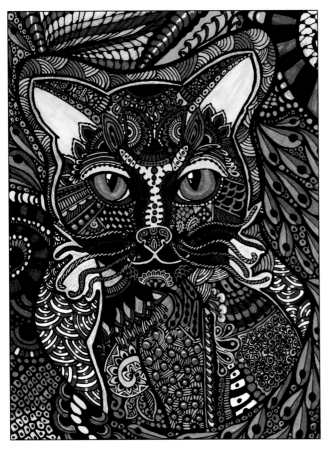

Markers, gel pens.
Color by Elaine Sampson.

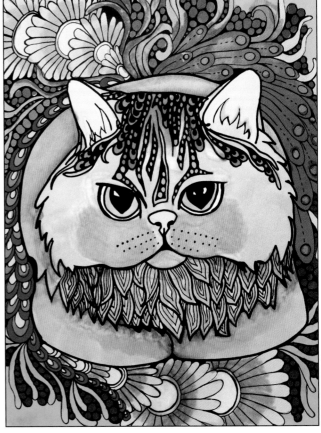

Markers (Sharpie, Tombow, Letraset ProMarkers, Bic).
Color by Brenda Abdoyan.

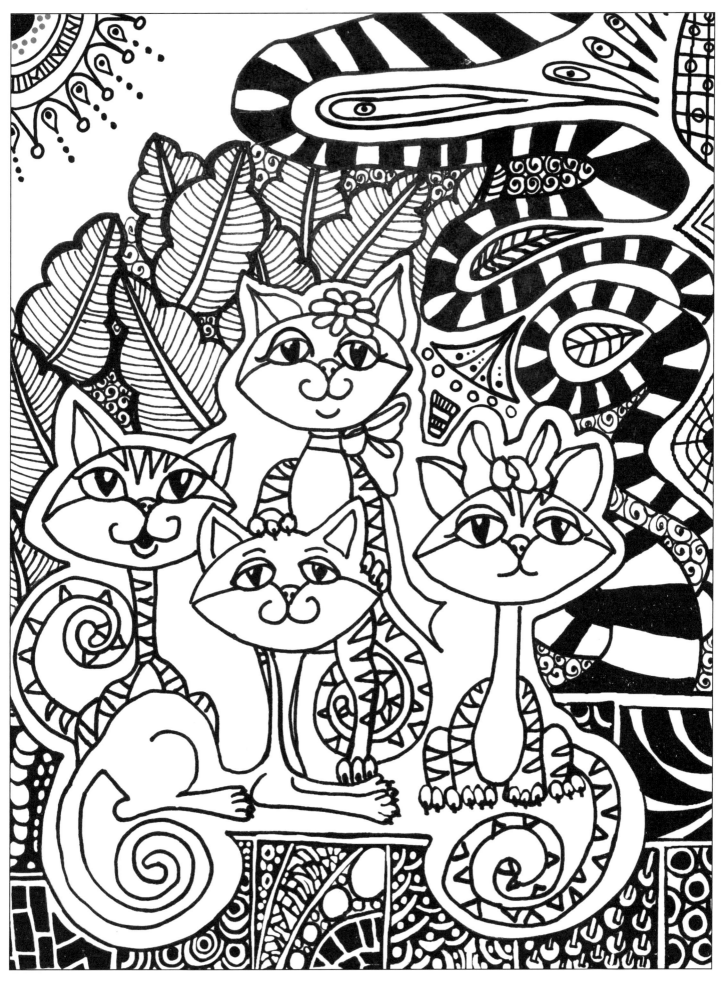

The way to get on with a cat is to treat
it as an equal—or even better,
as the superior it knows itself to be.

—ELIZABETH PETERS, *THE SNAKE, THE CROCODILE
AND THE DOG*

Band o' Cats

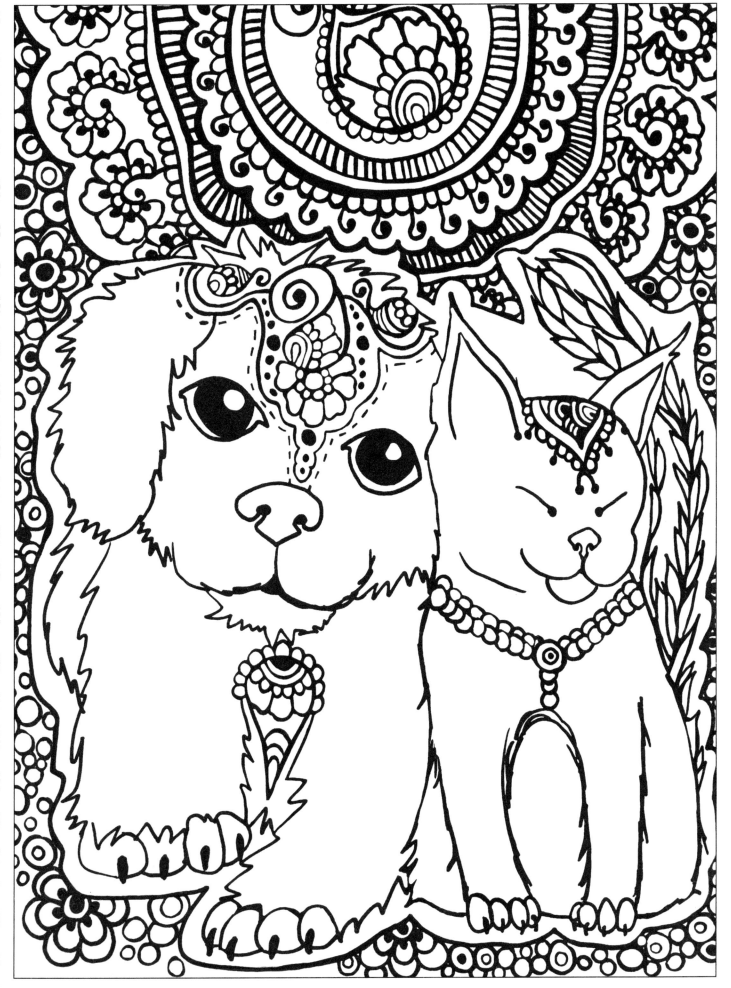

If a cat spoke it would say things like
"Hey, I don't see a problem here."

—ROY BLOUNT, JR.

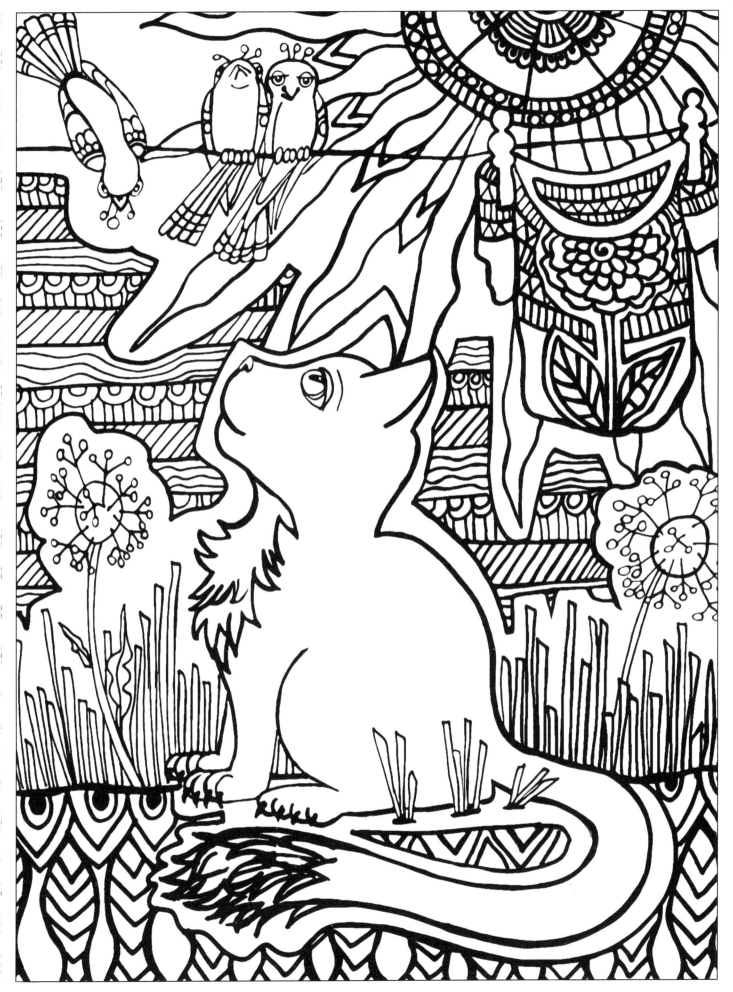

To do today:
Sit and think
Reach enlightenment
Feed the cats

—JAROD KINTZ, *I SHOULD HAVE RENAMED THIS*

Birds on a Wire

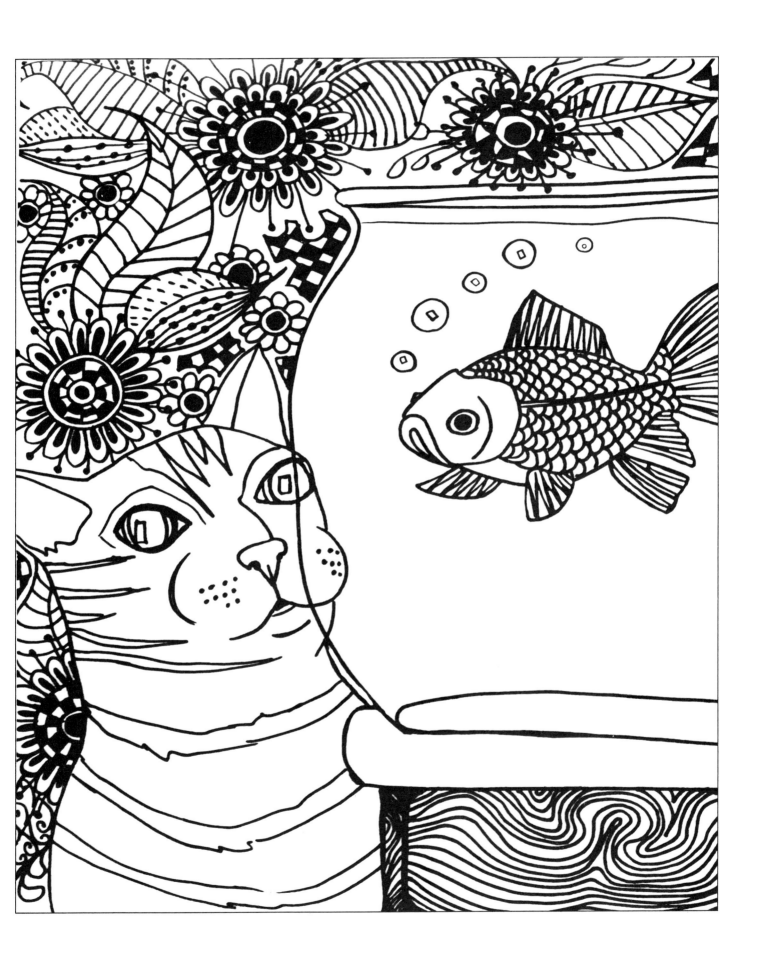

Dogs come when they're called;
cats take a message and
get back to you later.

—MARY BLY

Bubbles

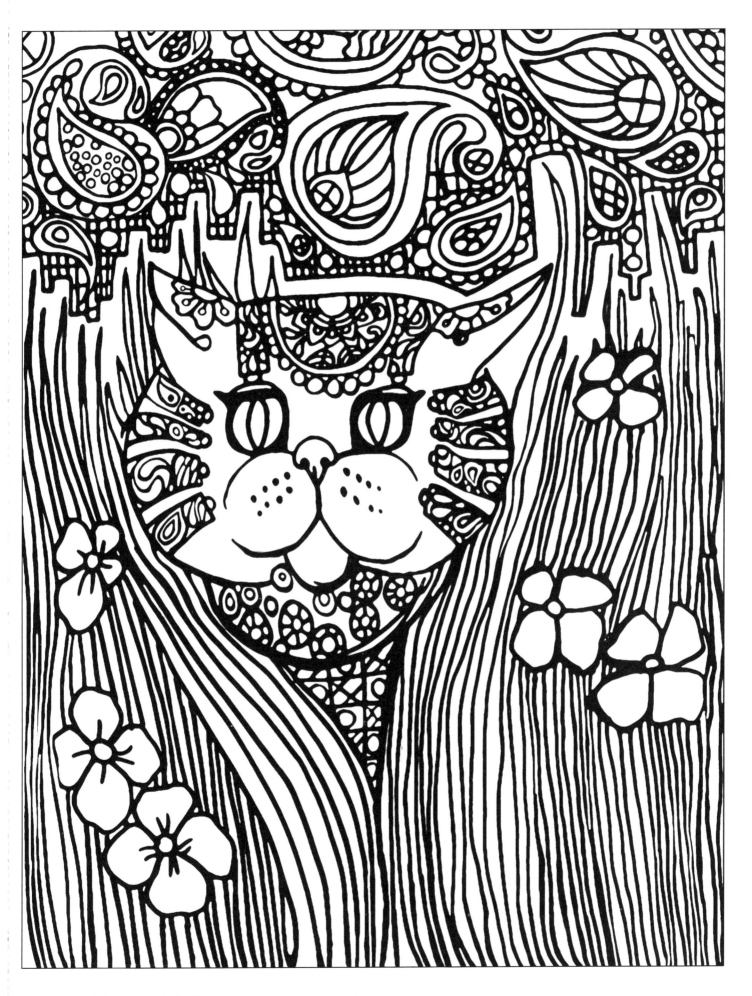

I would like to see anyone,
prophet, king, or God,
convince a thousand cats
to do the same thing at the same time.
—Neil Gaiman

Cat in the Grass

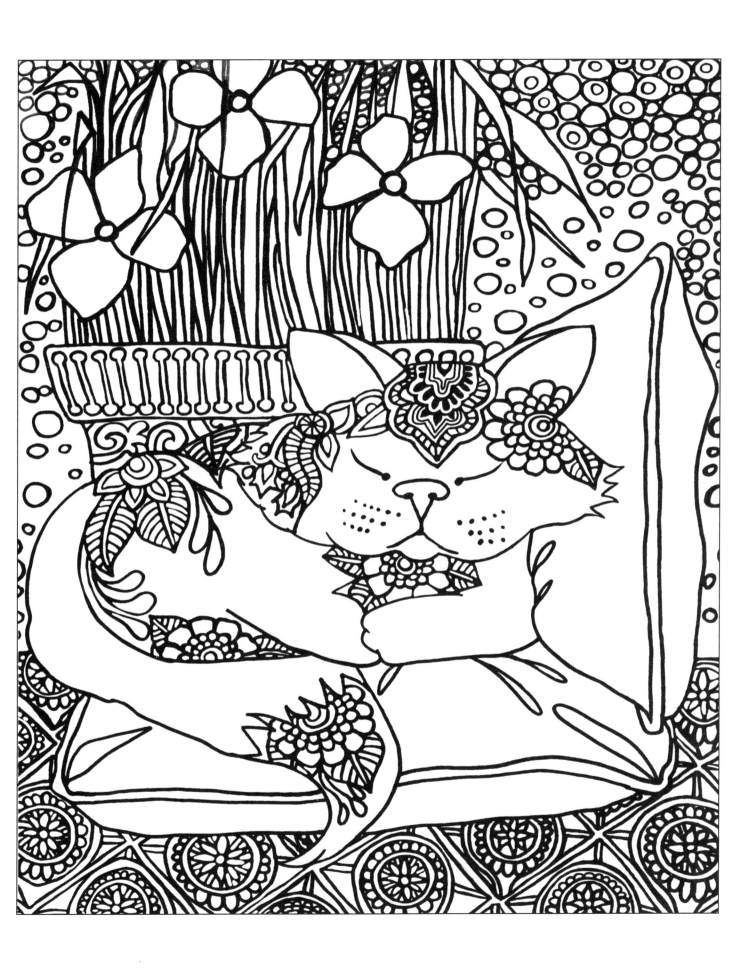

You cannot look at a sleeping cat
and feel tense.

—JANE PAULEY

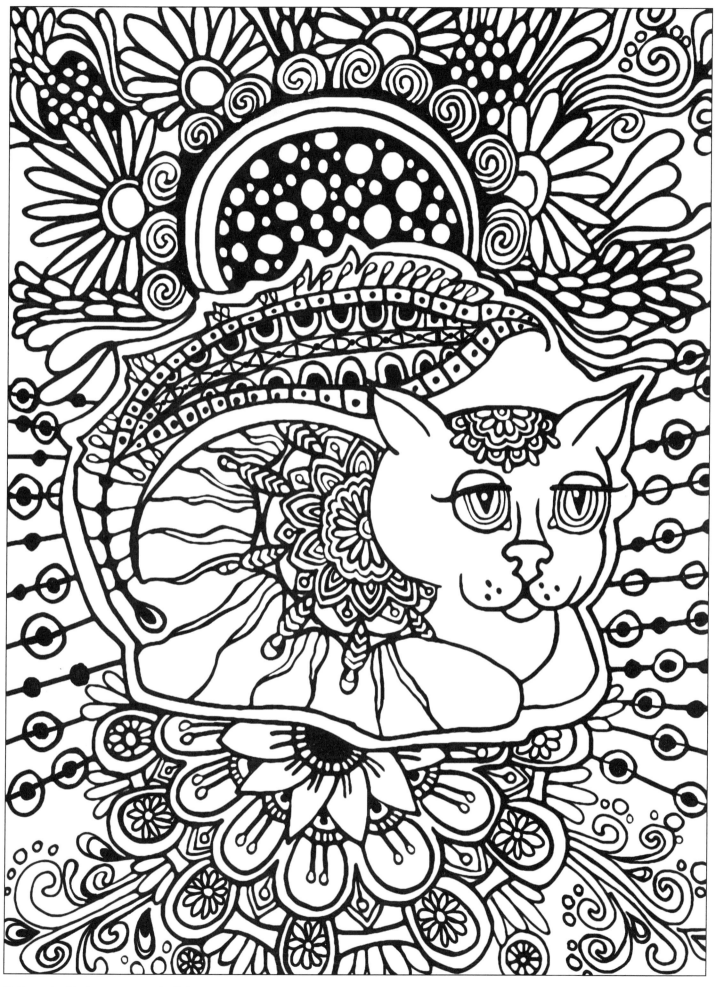

Women and cats will do as they
please, and men should just relax
and get used to the idea.

—ROBERT A. HEINLEIN

Chilly Cat

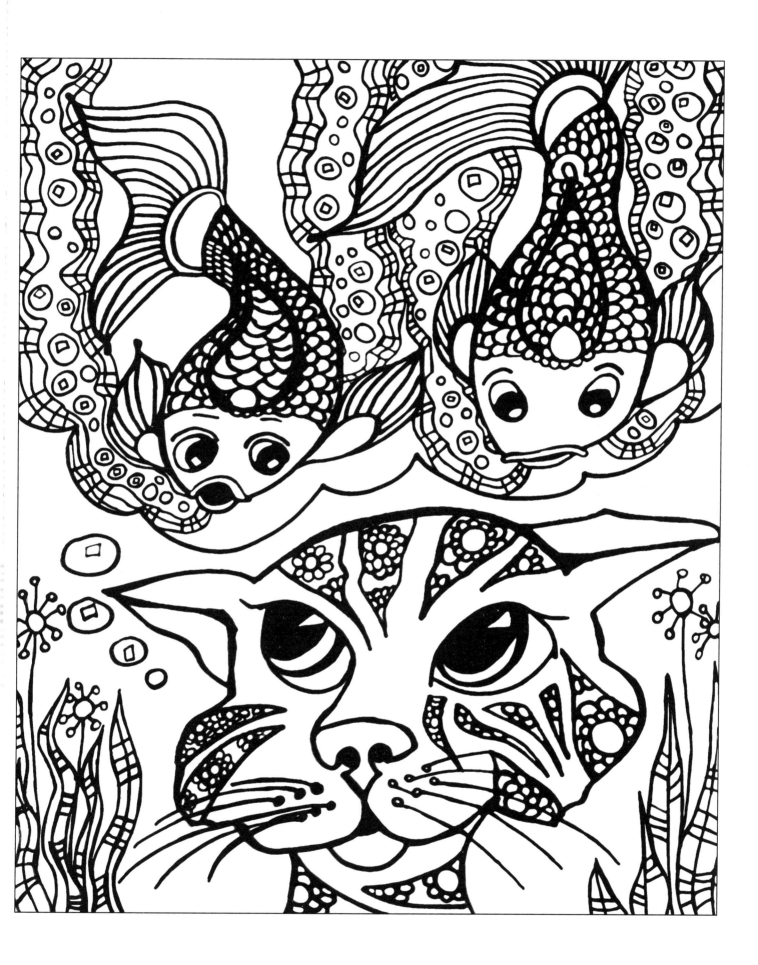

Cats, as you know,
are quite impervious to threats.

—CONNIE WILLIS, *TO SAY NOTHING OF THE DOG*

Daydreams

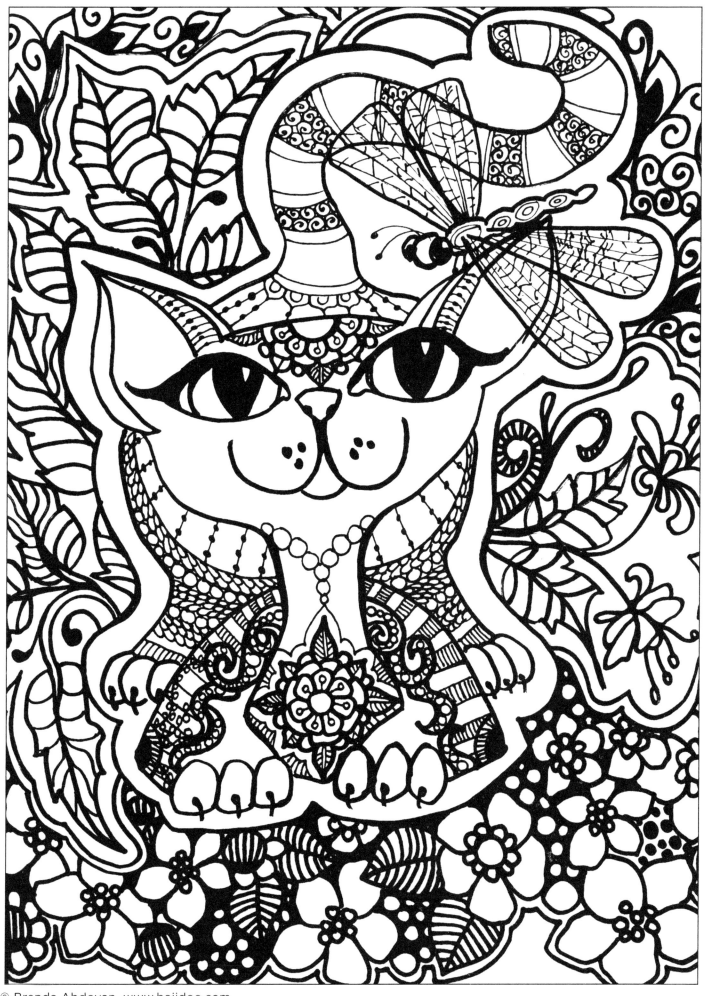

© Brenda Abdoyan, www.bajidoo.com

Cats have it all—admiration,
an endless sleep, and company
only when they want it.

—ROD MCKUEN

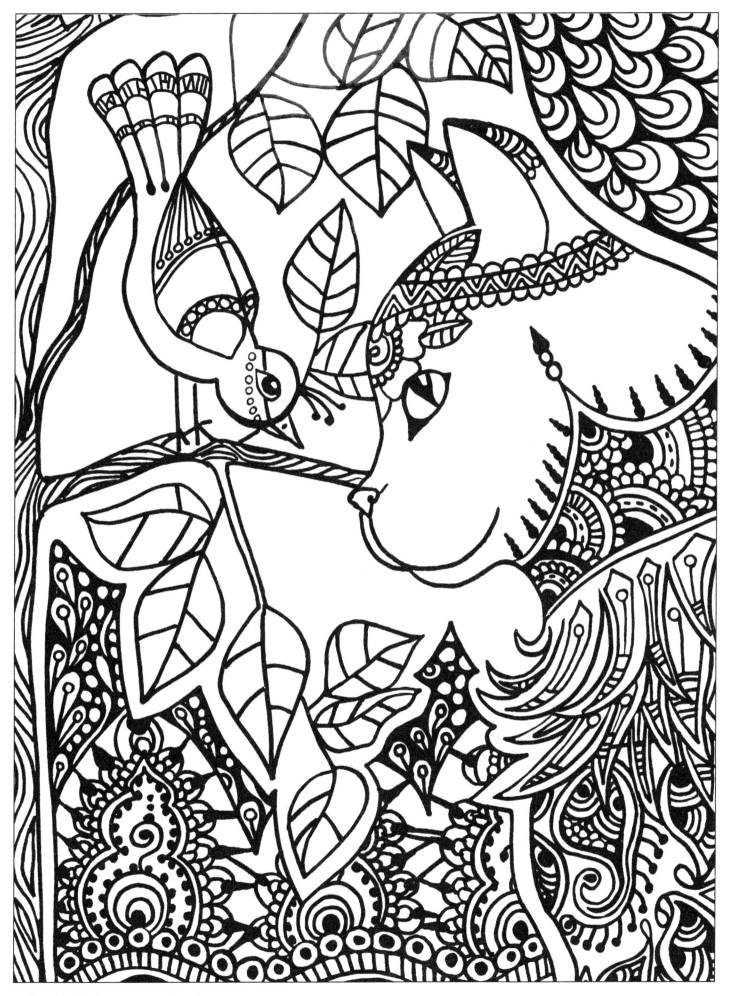

No valentines from the cats again.

—Lynne Truss, *Making the Cat Laugh*

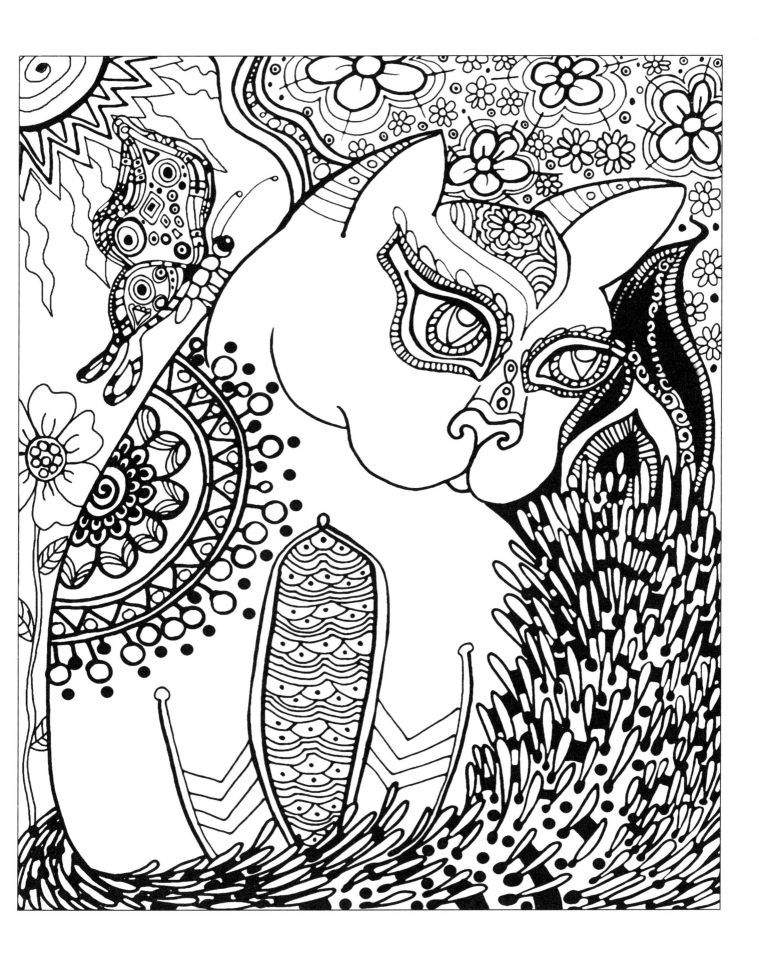

When Rome burned, the emperor's
cats still expected to be fed on time.

—SEANAN McGUIRE, *ROSEMARY AND RUE*

Fancy Cat

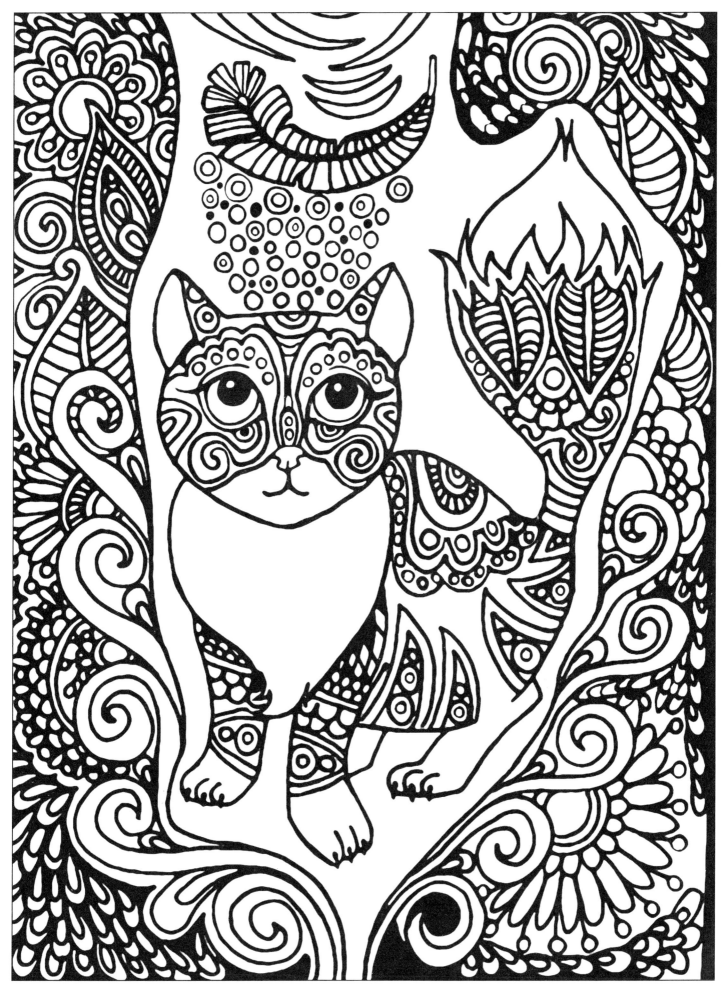

For a man to truly understand
rejection, he must first be ignored
by a cat.

—UNKNOWN

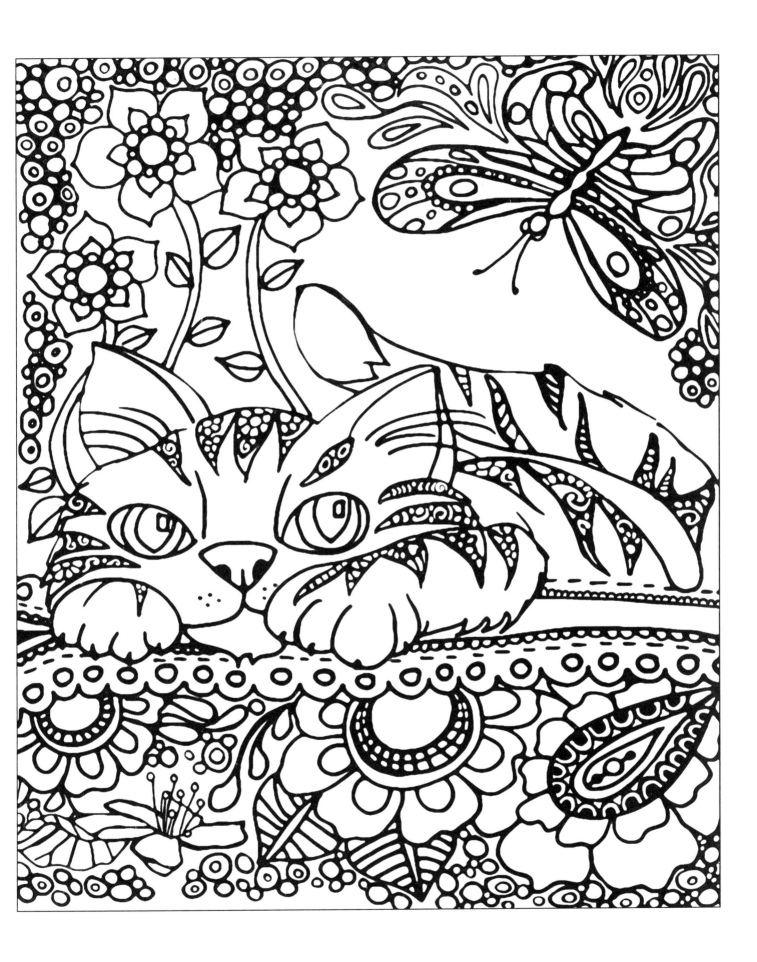

Letmeoutletme
outletmeoutletmeout.
Wait—let me back in!
Letmeinletme
inletmeinletmein.
Wait—let me back out!

—LEE WARDLAW, *WON-TON:*
A CAT TALE TOLD IN HAIKU

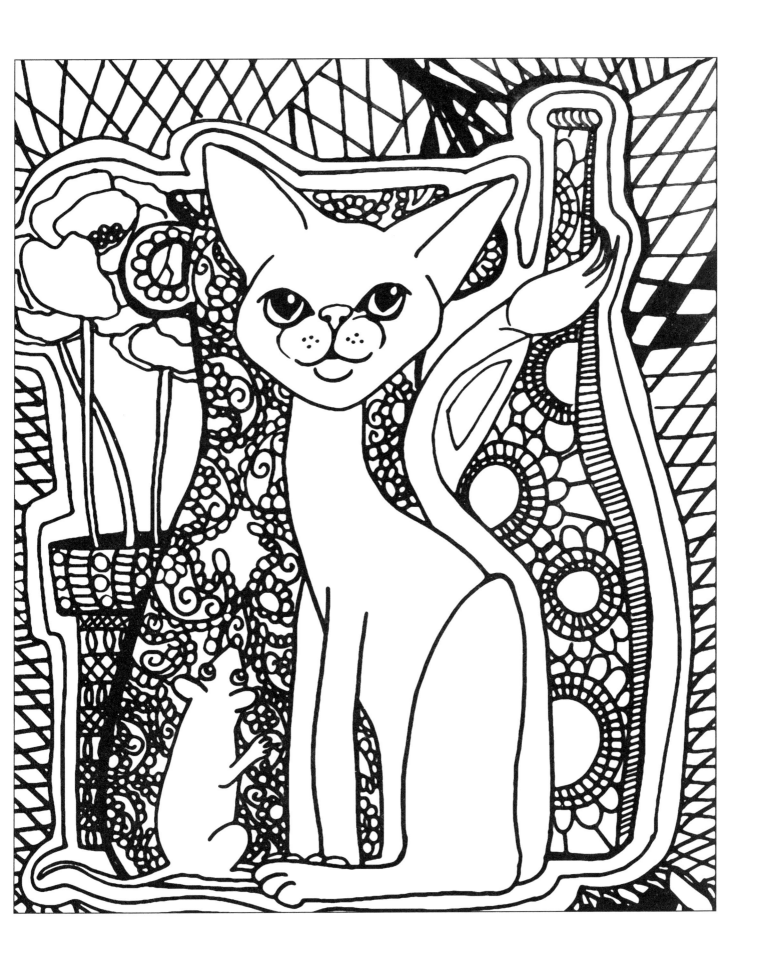

Cats are smarter than dogs.
You can't get eight cats to pull a sled
through snow.

—JEFF VALDEZ

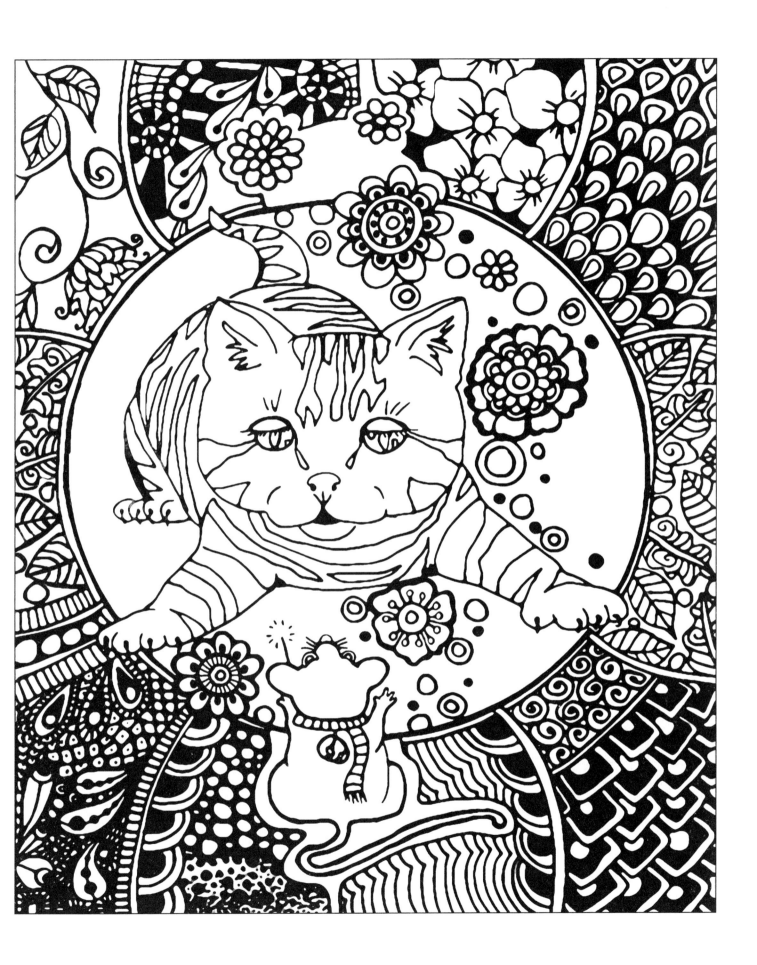

It always gives me a shiver when I
see a cat seeing what I can't see.

—ELEANOR FARJEON

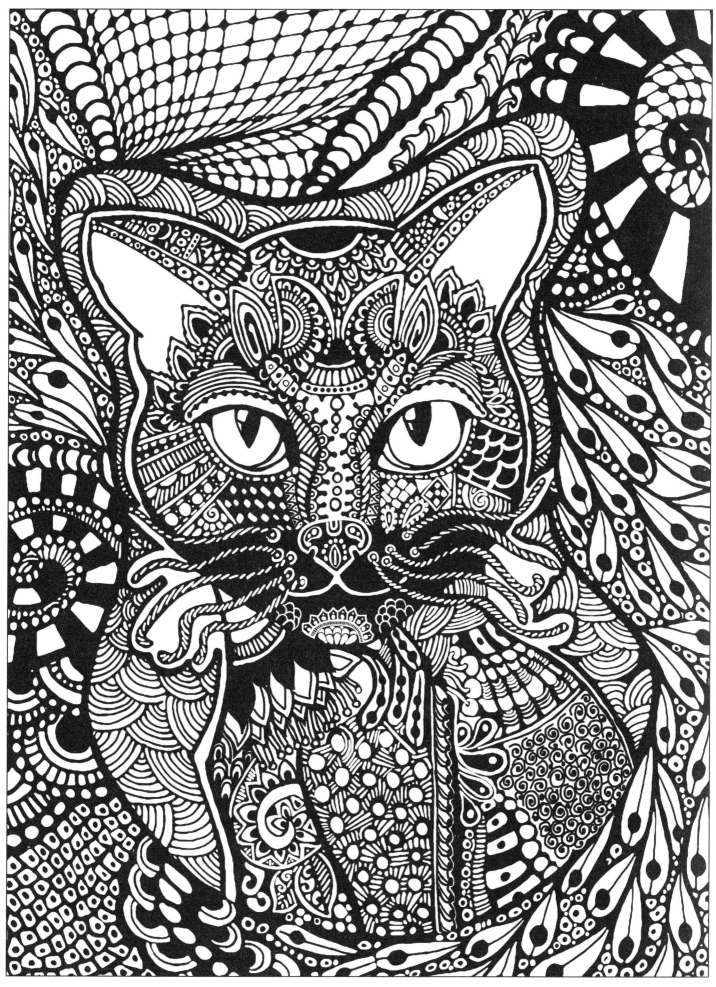

A cat has absolute emotional honesty.
Humans, for one reason or another,
may hide their feelings,
but a cat does not.

—ERNEST HEMINGWAY

Izzie Black Cat

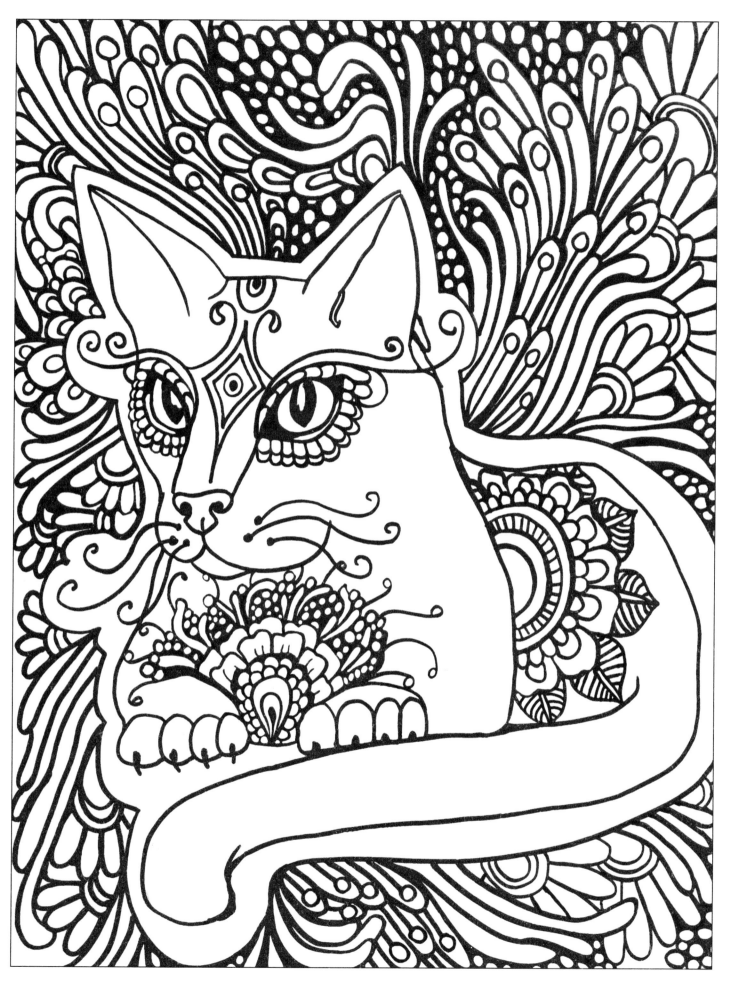

Way down deep, we're all motivated by the same urges. Cats have the courage to live by them.

—JIM DAVIS, CREATOR OF *GARFIELD*

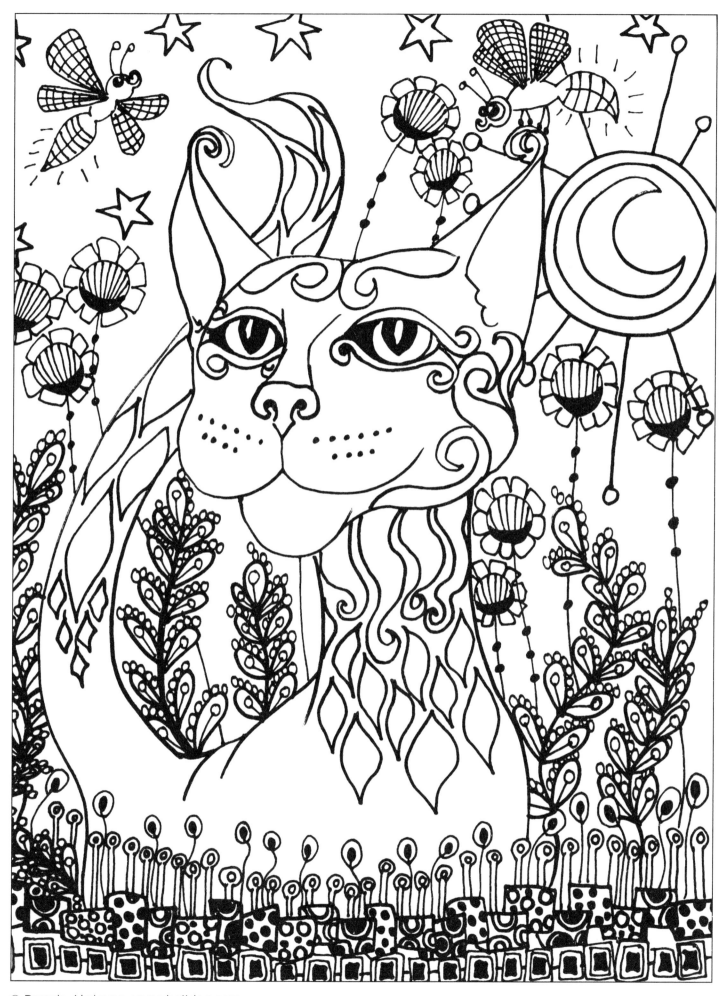

What greater gift
than the love of a cat?

—CHARLES DICKENS

Lion King

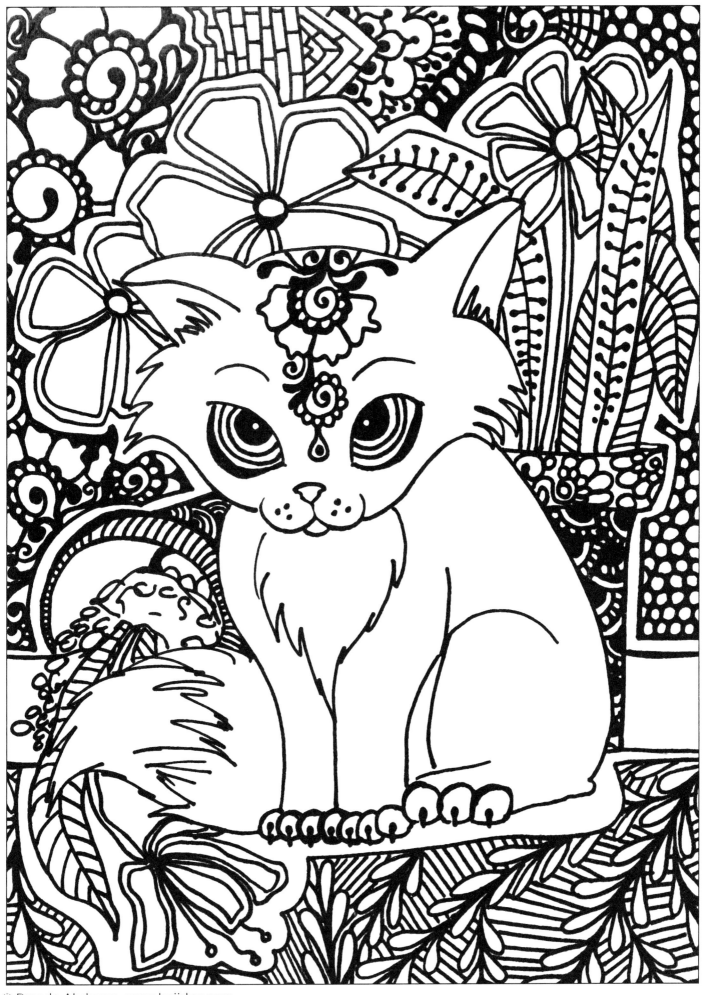

There is something about the presence
of a cat that seems to take the bite
out of being alone.

—Louis J. Camuti, *All My Patients Are Under
the Bed: Memoirs of a Cat Doctor*

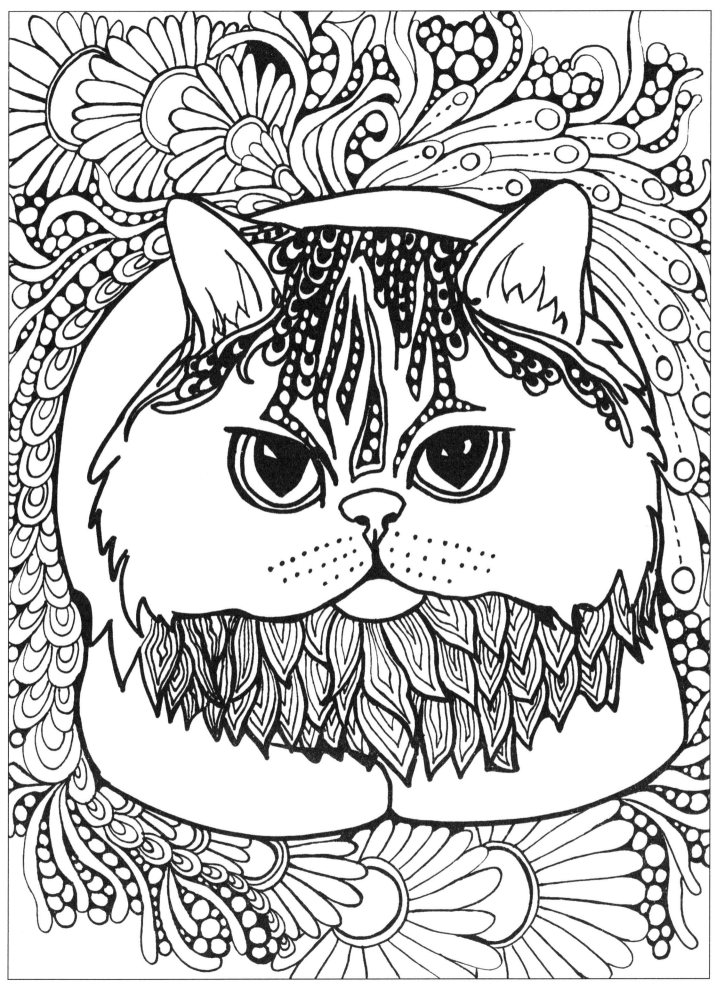

If animals could speak, the dog would
be a blundering outspoken fellow;
but the cat would have the rare grace
of never saying a word too much.

—MARK TWAIN

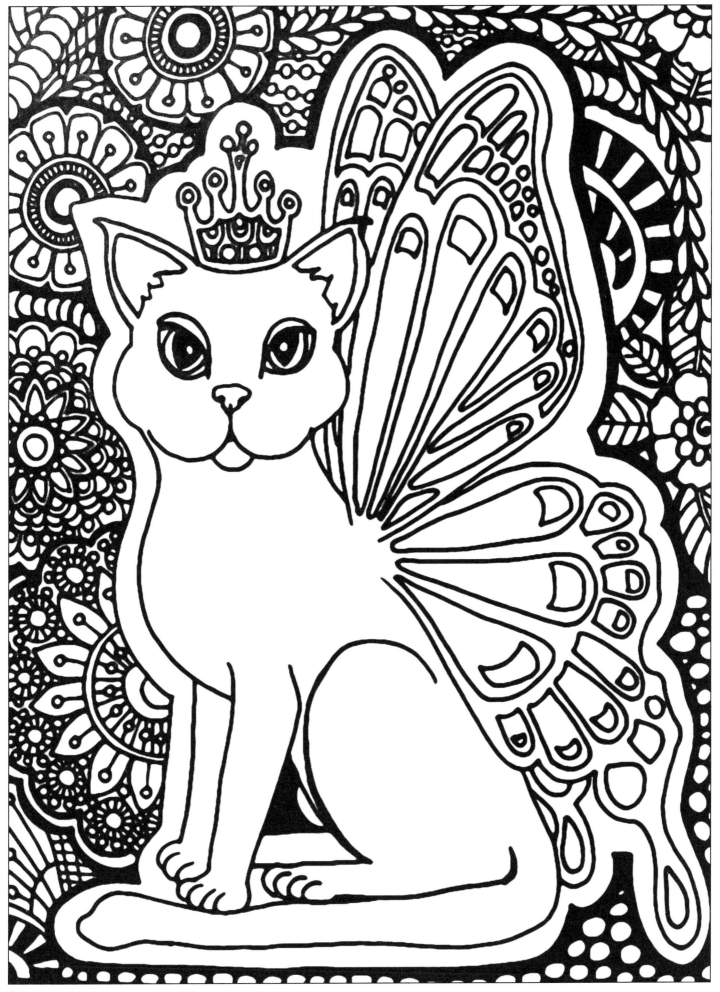

The cat could very well be man's best
friend but would never stoop
to admitting it.

—Doug Larson

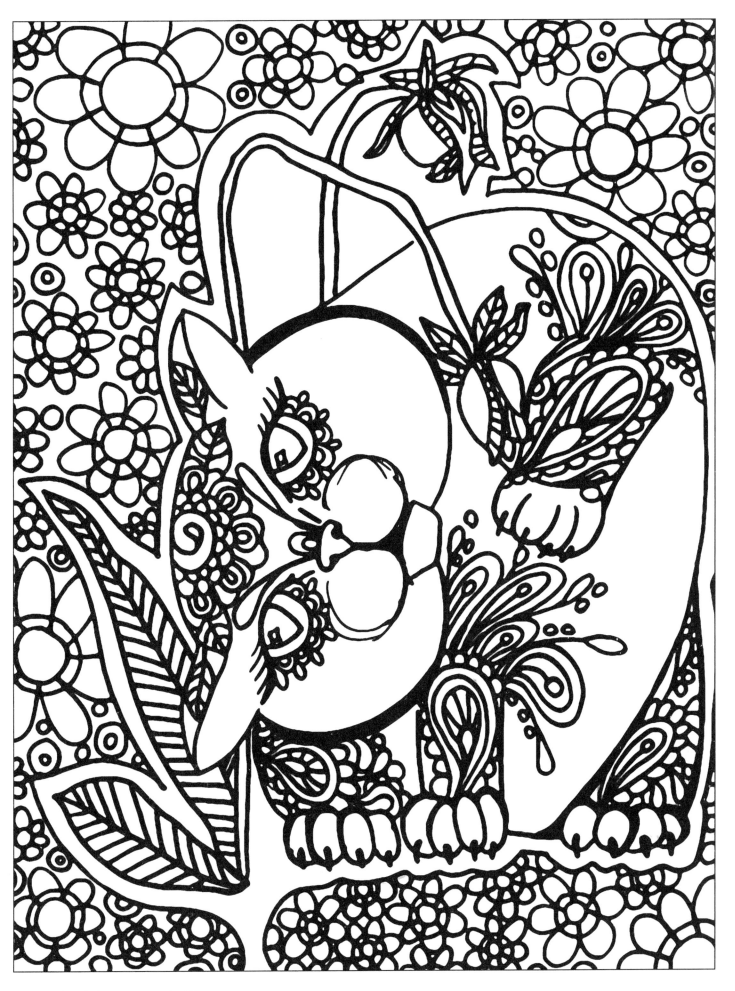

The cat is the only animal without
visible means of support who still
manages to find a living in the city.

—CARL VAN VECHTEN

Playing with Bluebells

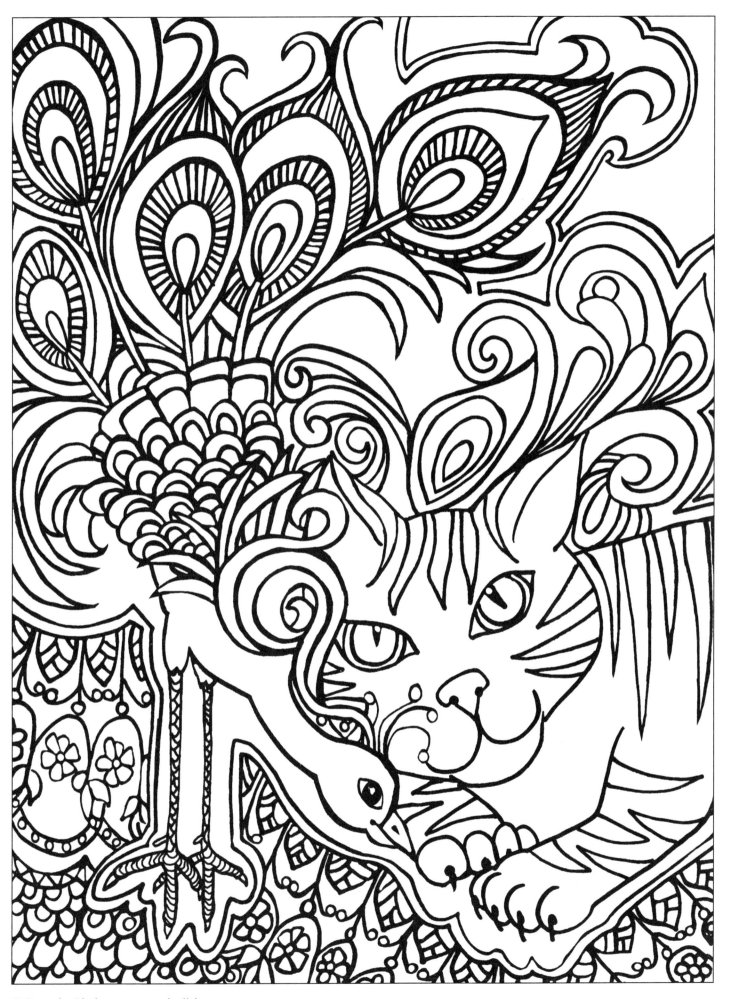

People meeting for the first time
suddenly relax if they find they both
have cats. And plunge into anecdote.

—CHARLOTTE GRAY

Purring Peacock

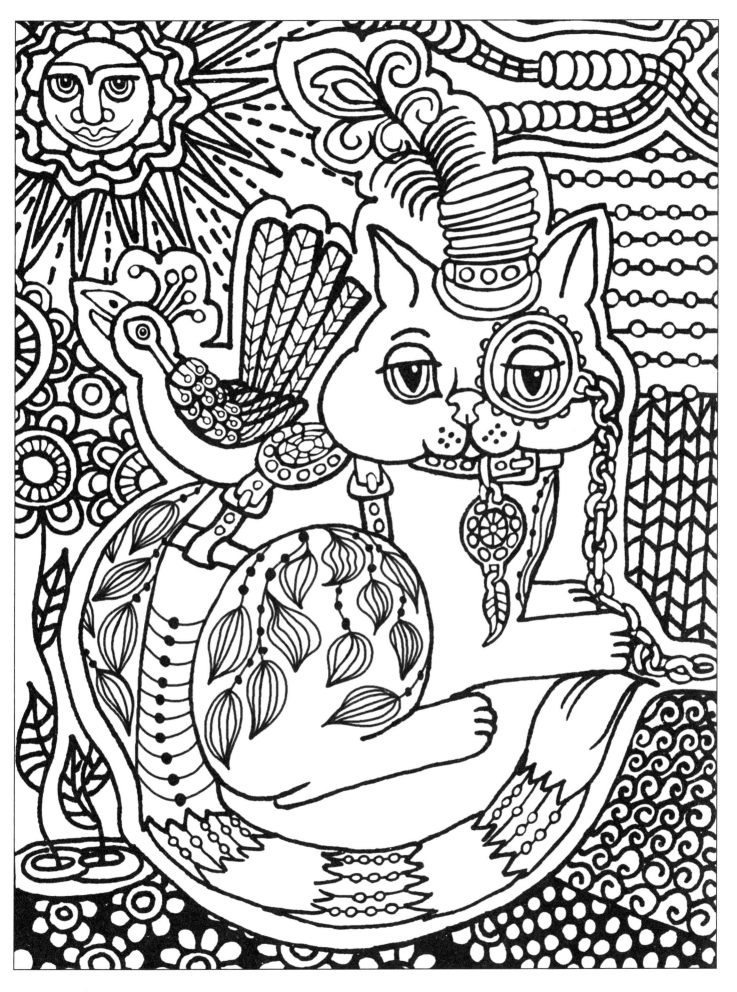

Cats seem to go on the principle that
it never does any harm to ask
for what you want.

—JOSEPH WOOD KRUTCH

Sammy

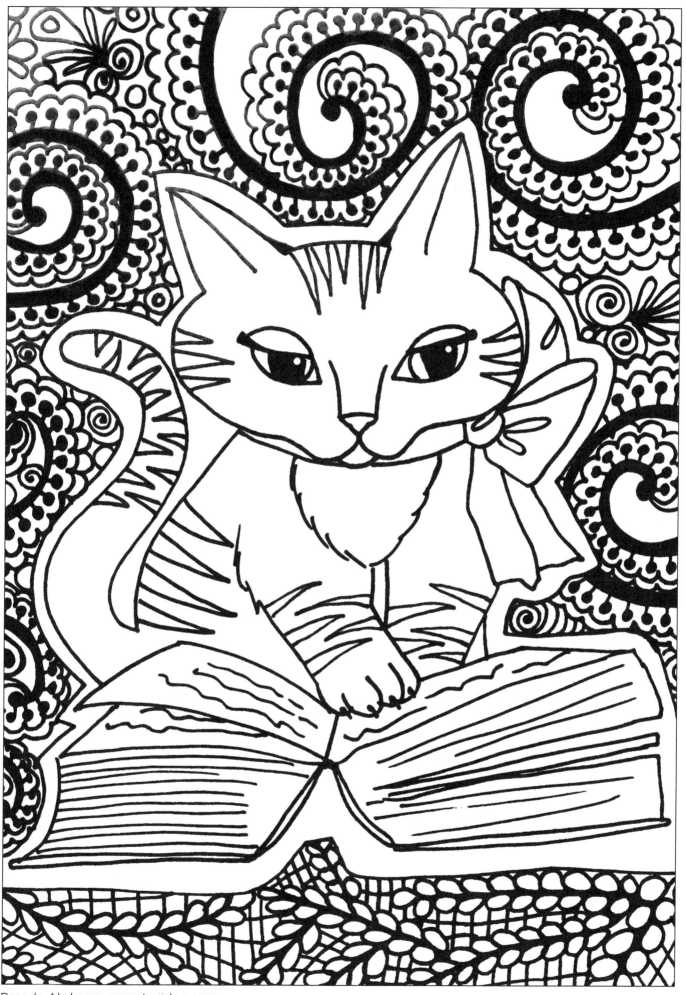

If you are worthy of its affection,
a cat will be your friend,
but never your slave.

—Théophile Gautier

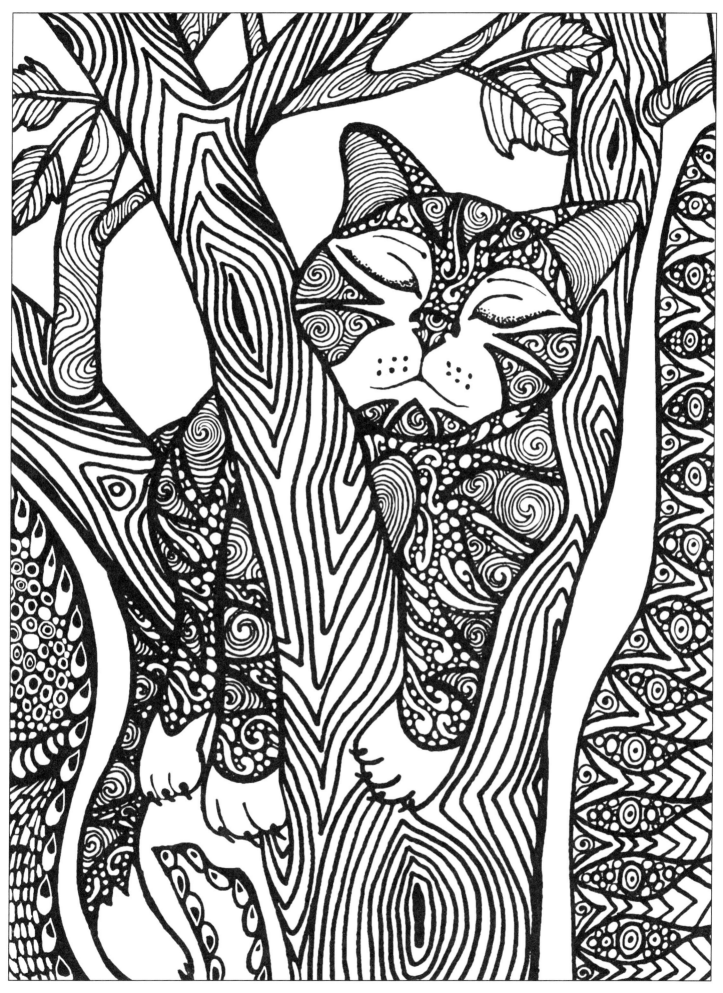

There's no need for a piece
of sculpture in a home that has a cat.

—WESLEY BATES

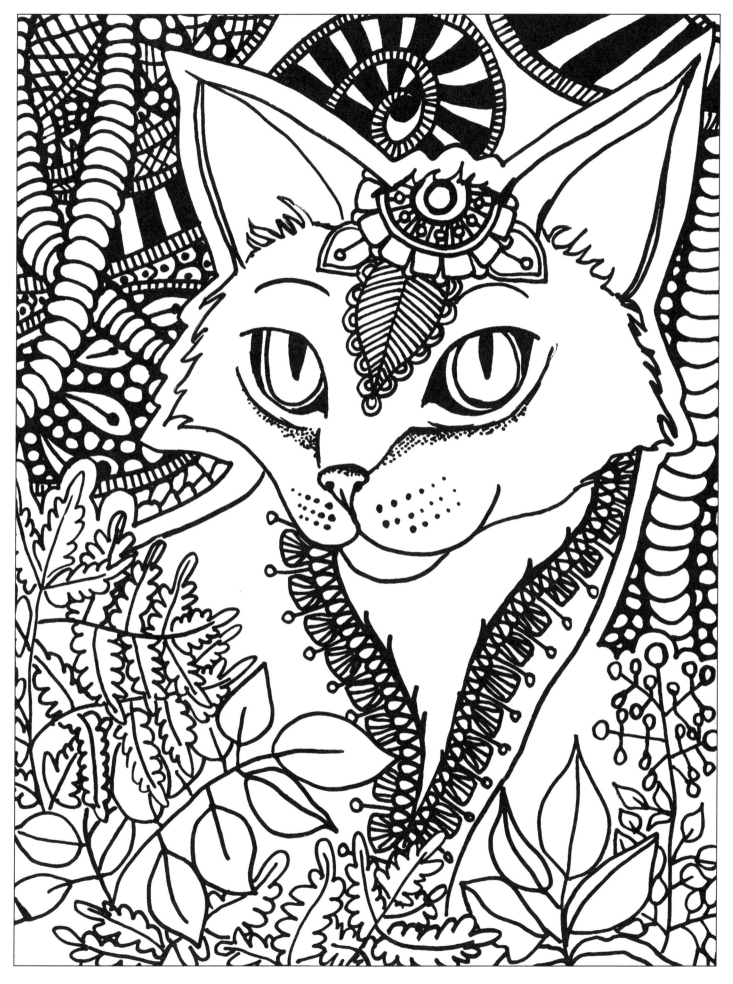

Cats come and go without ever leaving.

—MARTHA CURTIS

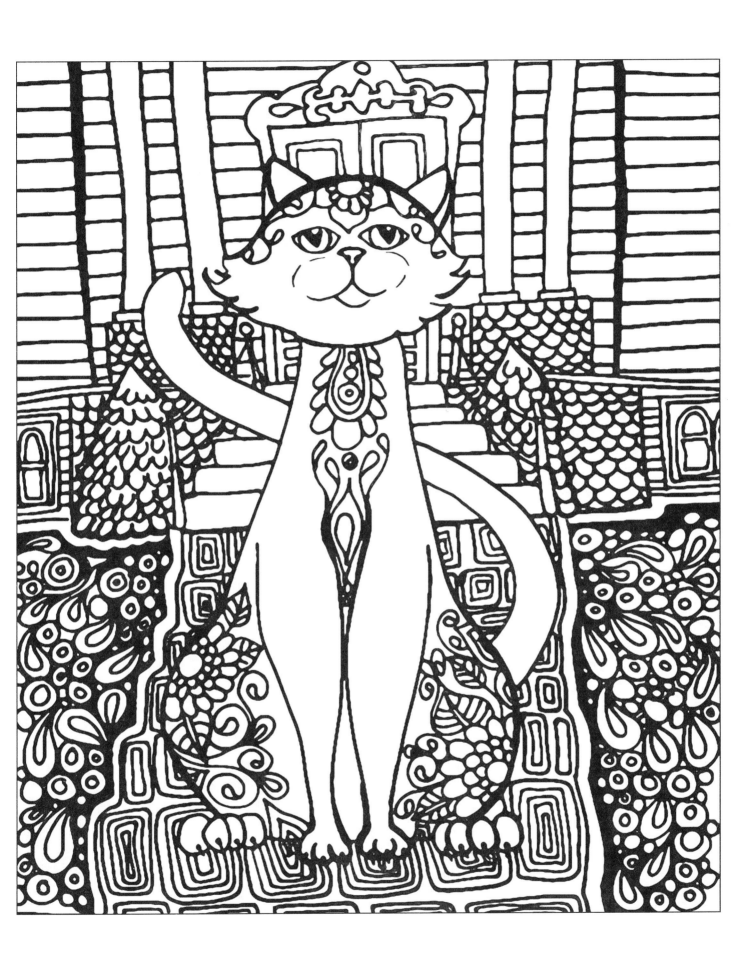

Time spent with cats is never wasted.

—MAY SARTON

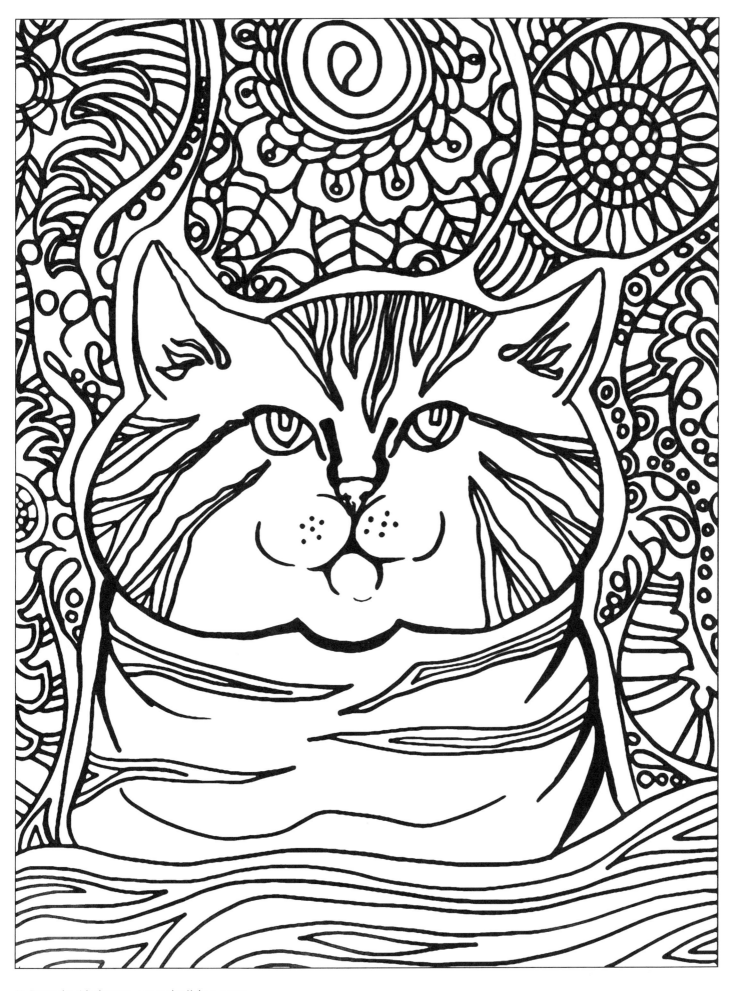

Dogs eat. Cats dine.

—Ann Taylor

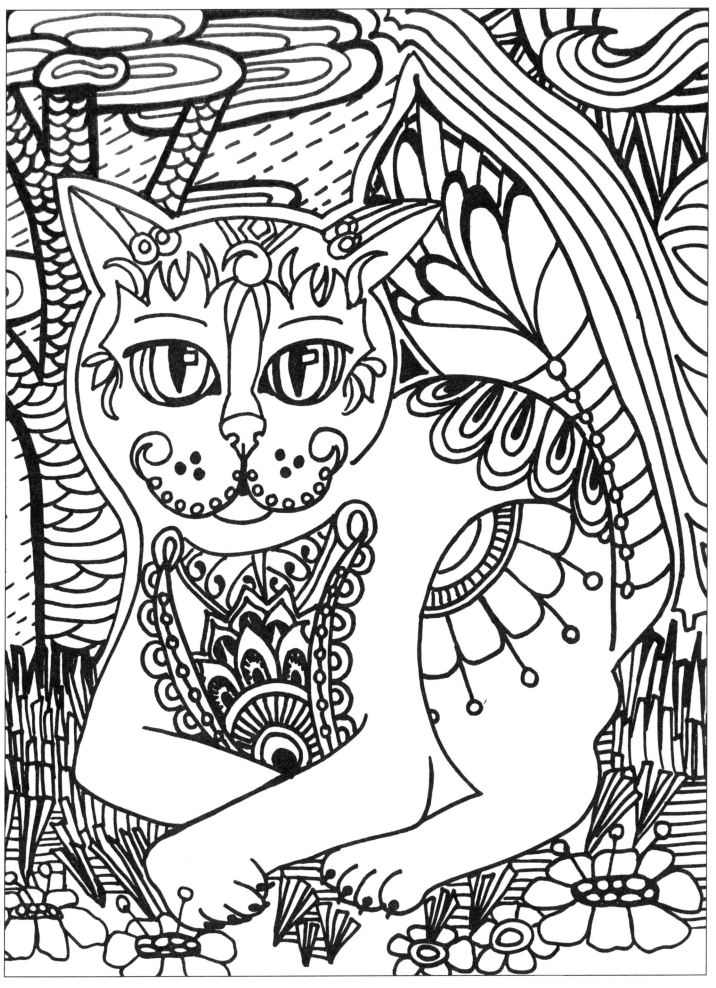

A cat is a puzzle
for which there is no solution.

—HAZEL NICHOLSON

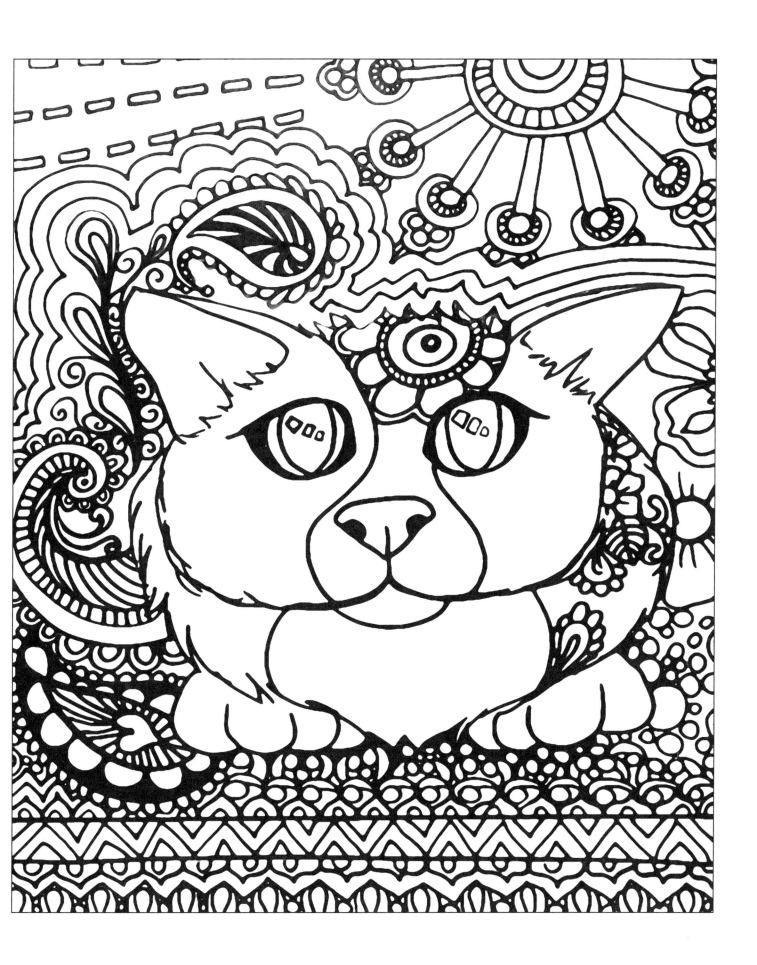

The problem with cats is that they get
the same exact look whether
they see a moth or an ax-murderer.

—PAULA POUNDSTONE

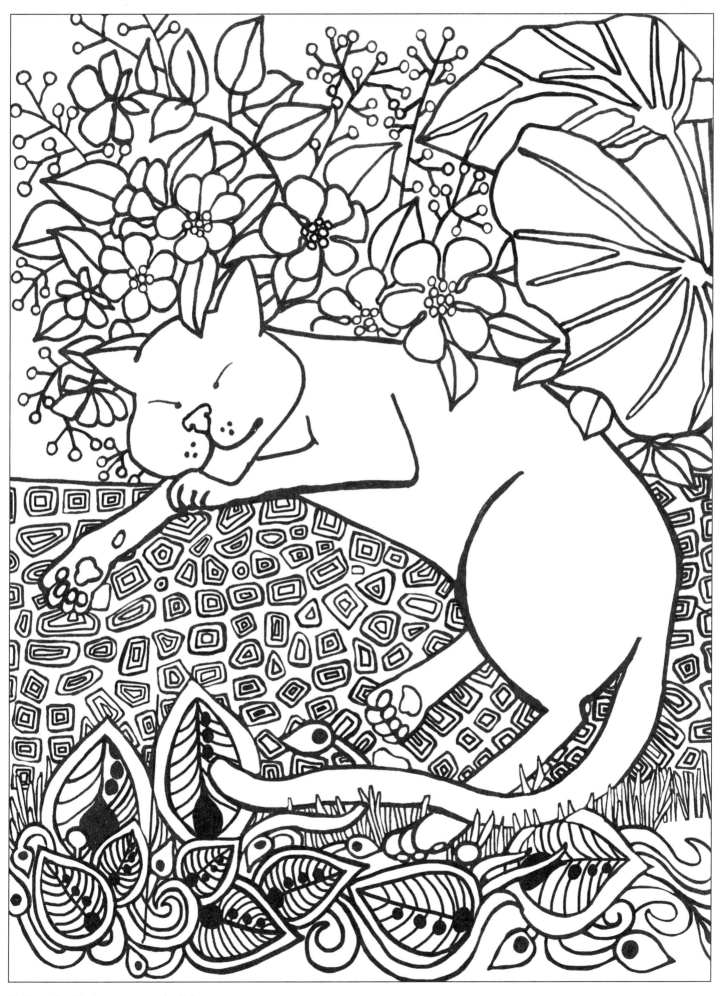

As every cat owner knows,
nobody owns a cat.

—ELLEN PERRY BERKELEY